Robert Rauschenberg

The Museum of Modern Art, New York

Robert Rauschenberg working on his
Stoned Moon series of lithographs at Gemini
G.E.L., Los Angeles, 1969

This book presents nine works selected from the nearly three hundred pieces by Robert Rauschenberg in the collection of The Museum of Modern Art. With the purchase of two photographs by Rauschenberg in 1952, the Museum became the first institution to acquire his works. His series 34 Drawings for Dante's Inferno (1959–60) (discussed here on p. 31) entered the collection in 1963 and was exhibited at MoMA in its entirety in 1966. In 1977 the Museum mounted a midcareer retrospective of Rauschenberg's work—described in *The New York Times* that year as "the finest art of its time"—marking his prominent place in postwar modernism. MoMA acquired several important early works by the artist in the late 1990s, including *Untitled (Asheville Citizen)* (p. 5) and *Factum II* (p. 25). Curator Kirk Varnedoe organized a special exhibition around them, describing Rauschenberg as a "deft, even surgical practitioner of what came to be called Conceptual art" and a "restless experimenter with an omnivore's appetite for exuberant physicality and imagery impetuously seized from life." This book is one in a series featuring artists represented in depth in the Museum's collection.

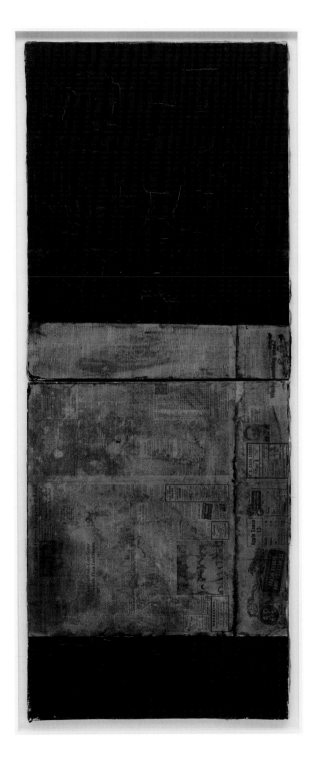

Untitled (Asheville Citizen)

(c. 1952) By the summer of 1952, when Robert Rauschenberg was finishing this painting, he bore little resemblance to the eighteen-year-old who had left his hometown of Port Arthur, Texas, nine years earlier not "even knowing there was art." Indeed, his expanded knowledge combined with what one critic called "an acrobatic intelligence" was rapidly turning him into the *enfant terrible* of the New York art world. Using the GI Bill, he had studied—albeit idiosyncratically and selectively—at the Kansas City Art Institute, the Académie Julian in Paris, and, more significantly, at Black Mountain College in Asheville, North Carolina, where the former Bauhaus master Josef Albers found Rauschenberg an almost unbearably irritating pupil yet left him with ideas that served him for decades. In 1949, at the end of his first year at Black Mountain, Rauschenberg shifted his apprenticeship to New York, where he studied at the Art Students League and, with more persistent efforts, turned his attention to becoming part of the city's art scene.

Returning to Black Mountain in the summer of 1951, he

tled (Asheville Citizen) c. 1952
and newspaper on canvas, two panels,
" x 28 ½" (188 x 72.4 cm)
Museum of Modern Art, New York.
chase, 1999

found Albers gone and the college transformed, as Walter Hopps put it, into "a galvanic cultural outpost of the New York art world." Among the many luminaries gathered there, the most important for Rauschenberg was John Cage (fig. 1), who has characterized their rapport as a "sense of absolute identification, or utter agreement." Coincident with their meeting, Rauschenberg began an extraordinary succession of paintings—a first series in white (fig. 2), a second in black. Perhaps appropriately for works that might seem embodiments of the positive and the negative, Rauschenberg's approach drew almost equally on the harmony of his thought with Cage's and its disharmony with the theories of Albers. Cage's Zen-influenced ideas of art as a passive field where chance and randomness, nature's structuring principles, might freely operate were given material form in Rauschenberg's white monochrome surfaces. They were, to Cage's delighted perception, "landing strips for dust motes, light and shadow." The decision to make the White and Black series was, however, a more direct reaction to Albers's injunction that the artist should "make colors and forms do something they don't want to do themselves." That notion ran against the grain for Rauschenberg, who commented, "I didn't want painting to . . . achieve some predetermined result. . . . I didn't want color to serve me. . . . That's why I ended up doing the all-white, and the all-black paintings—one of the reasons, anyway."

One of the most innovative and challenging works from the Black series is *Untitled (Asheville Citizen)*, which shares part of its name with the college's local newspaper. Tall and narrow, it consists of two canvas panels of equal size, their division

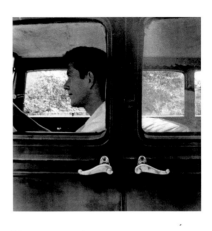

bridged by sheets of newspaper positioned between a large vertical rectangle of uninflected black paint at the top and another smaller horizontal one at the bottom. A structure at once phlegmatic and cunning, it acts just about exactly how Rauschenberg had hoped his black paintings would: "I was interested in getting complexity without their revealing too much. In the fact that there was much to see but not much showing. I wanted to show that a painting could have the dignity of not calling attention to itself, that it could only be seen if you really looked at it."

While *Untitled (Asheville Citizen)* preserves its dignity and backs off from any visual histrionics, it nonetheless exercises a quiet come-on keyed to the performance of the newspaper area. Although collaged newsprint descends in a venerable line from Picasso and Cubism, Rauschenberg's use of it was virtually without precedent. Where the classic Cubist collage employs an artfully selected fragment cut from its original page to play a supportive—sometimes narrative, punning—role in an overall composition, this picture's newspaper sheets are unmolested, tampered-with only sufficiently to accommodate their dimensions to those of the underlying canvas panels. On the

7

1 Unknown photographer
John Cage, Black Mountain 1952
Gelatin silver print, 14 ¾ x 14 ¾"
(37.5 x 37.5 cm)

right, placed sideways, is a portion of the eponymous news-
paper's August 3, 1951, issue and, in a parallel position on the
left, a page from that of March 29, 1952. The only differentiated
mark-making or "drawing" in the painting is in the lines—in fact,
indentations—horizontally demarcating the join between the two
panels and vertically between the two newspaper pages. The
asymmetrical positioning of the newspaper area on the canvas
tends to disallow immediate recognition of the picture's panels
as equal physical partners, a phenomenon alternately countered
and reinforced by visual rhyme. The horizontal line across the
middle of the painting turns the panels into fraternal twins,
with the proportion of painting to newspaper at the top reversed
in the lower panel and, at the same time, echoed and again
inverted within the newspaper area alone. There, the vertical line
8 disrupts the evenly balanced patterning just enough to animate

2 *White Painting (Three Panel)* 1951
Oil on canvas, 6 x 9' (182.9 x 274.3 cm)
San Francisco Museum of Modern Art.
Purchased through a gift of Phyllis Wattis

the composition and concentrate the eye on an up-and-down scanning. Hopps described *Untitled (Asheville Citizen)* as an "explicit rhythmic drama" where "the compositional devices unite in visual syncopation."

The pictorial syncopation Hopps noted is abetted by the way the newspapers are mounted. The sheets have been rotated ninety degrees, their innate geometries emphasized by lines of type doubling as vertical and horizontal stripes aligned with the outside edges of the panels. Thus, a crossword puzzle, wrestling and baseball news, a supermarket's ad for applesauce, and sundry other printed items bring in the chance juxtapositions of everyday life while simultaneously assuming the flat appearance of Mondrianesque patterning. Given the many discreet visual pleasures *Untitled (Asheville Citizen)* affords, its economy of means is all the more remarkable. Hopps was firm about its absolute status: "No spatial allusion resides in this work. It is pure factum."

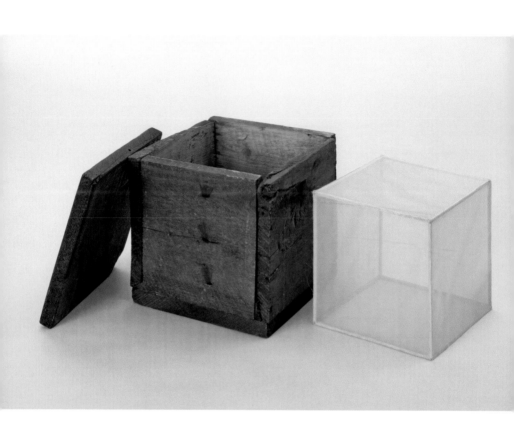

Untitled c. 1953
Wood box with lid and removable balsa-
wood-and-fabric cube, box with lid:
7 ⅛ x 7 ⅛ x 7 ⅛" (18 x 18 x 18 cm); cube:
5 ⅝ x 5 ⅝ x 5 ⅝" (14.2 x 14.2 x 14.2 cm)
The Museum of Modern Art, New York.
Purchase, 1999

Untitled (c. 1953)

A master of impure dualities, Rauschenberg once observed that he tends "either to make something so simple that you can't remember it or so complicated that you can't remember it." This hauntingly memorable, seemingly uncomplicated box in a box would seem to refute its author's assessment were it not so rich in formal and associative dynamics. It is one in a series of objects Rauschenberg produced beginning in the spring of 1953 after an extended stay in Europe and North Africa with the artist Cy Twombly. Rauschenberg specifically designated these new works "elemental sculptures"; it was his purpose to draw attention to their fundamental nature, to the sculptural structuring of their basic units as opposed to the kind of imagined tribalism that had pervaded his *Scatole personali* (Personal boxes) of the previous year (fig. 3).

When the elemental sculptures and the last of his Black paintings made their debut in an exhibition Rauschenberg shared with Twombly in New York that September at the Stable Gallery, they met almost exclusively negative criticism. One

11

3 *Untitled (Scatole personali)* c. 1952
Assemblage: lidded painted wood box with
painted interior, with painted fabric, thorns,
and snail shells, 5 x 5 ½ x 5 ⅜" (closed)
Collection Jasper Johns, New York

piece, *Untitled (Elemental Sculpture)* of about 1953 (fig. 4), may be the one singled out by a prominent critic as "a caveman's noggin knocker." Though most reviews were condescending or dismissive, the show was a *succès de scandale*, anointing Rauschenberg as the new wild man of the American vanguard. Not since Jackson Pollock had there been a noisier arrival.

For reasons unknown, the untitled piece that is the subject of this commentary was not included in the Stable Gallery exhibition. While it would later elicit special admiration from important critics, it is unlikely that a 1953 exposure would have affected reactions to Rauschenberg's work that year. One simple geometric object enclosing another smaller one of the same shape, to be left as is or rearranged, this work anticipates what Minimalist artist Donald Judd would later tout as a "specific object." But reflecting his time and temperament, Rauschenberg wanted to invest formalist structure with the life of its materials. He was, however, nicely aware of the revolution brought about some four decades earlier when Picasso's *Guitar* of 1914 replaced sculpture's traditional carving and modeling of mass with construction in space. Accordingly, this sculpture observes the earlier and the later modes. To borrow words from the poet Marjorie Welish, it "flaunts a duality as though it were a unity." Closed, its contents hidden, the outer box appears as mass. Open, with the inner cube removed and in any proximal position, it becomes two echoing volumetric structures. Welish sees the piece as "abstract sculptural thinking accomplished in the most rigorous terms: . . . modern attitudes toward sculpture being literally encapsulated in this material statement."

Typically for a work by Rauschenberg, this untitled sculpture is open to manifold interpretations. It almost literally reflects a belief the artist and John Cage shared that "there was enough room for every mind to have a different thought." Nan Rosenthal, Rauschenberg's friend and a noted scholar of his work, remarked that the "little fabric box is also a kind of three-dimensional picture of one of his white monochrome canvases" (such as fig. 2). In the context of his definitive book on Rauschenberg's early works, Walter Hopps interweaves an articulate inventory of the piece's constituent parts with contextual reading: "The cube in box sculpture consists of a rough, imprecise, lidded wood box. . . . Inside and unattached is a delicate, translucent, precise cube that Rauschenberg constructed of balsa wood struts and sheer silk fabric. . . . The simple, formal dynamics of this sculpture are remarkable and make explicit a poignant interdependence between fragility (the pure cube soul) and sturdiness (the functional exterior shelter)."

13

4 *Untitled (Elemental Sculpture)* c. 1953
Hinged steel flange, steel strap, iron
bolt, and stone, 13⅝ x 18¼ x 9⅛"
(34.6 x 46.4 x 23.2 cm)
San Francisco Museum of Modern Art.
Purchased through a gift of Phyllis Wattis

Bed (1955)

It is unlikely that anyone other than Rauschenberg has speculated that a viewer might be possessed of an urge to occupy this bed. At its first showing it reminded one reviewer of "a police photo of the murder bed after the corpse has been removed," an interpretation widely shared—and amplified—over the years. Rauschenberg, however, claimed that this reading was wholly at variance with his own: "I think of *Bed* as one of the friendliest pictures I've ever painted. My fear has always been that someone would want to crawl into it." Whatever measure of sly amusement there must have been in this response, it implicitly acknowledges the double identities of this object—first as a picture and second as a bed. It was fashioned as an arena for cognitive collisions and it has gone about producing them for decades.

Once hanging on the wall of a celebrated collector, now gracing one in The Museum of Modern Art, *Bed* ambushes unprepared visitors every day. Like most of the neighboring objects in the Museum's collection, it is composed of fabric stretched over a wooden structure and selectively covered with paint—but it is manifestly not a picture *of* anything: it is a bed, seen not from above but in direct vertical address. In this work Rauschenberg's gestural handling of paint is a clear reference to Abstract Expressionism, but the artist chose to reverse the procedures Jackson Pollock had famously instated only a few years previously. Where Pollock had positioned commercially supplied canvas on the floor in order to fling, drip, and otherwise apply paint from above, Rauschenberg upended the normally supine components of his bed into a traditional easel stance that

14

Bed 1955
Oil and pencil on pillow, quilt, and sheet on wood supports, 6' 3 ¼" x 31 ½" x 8" (191.1 x 80 x 20.3 cm)
The Museum of Modern Art, New York. Gift of Leo Castelli in honor of Alfred H. Barr, Jr., 1989

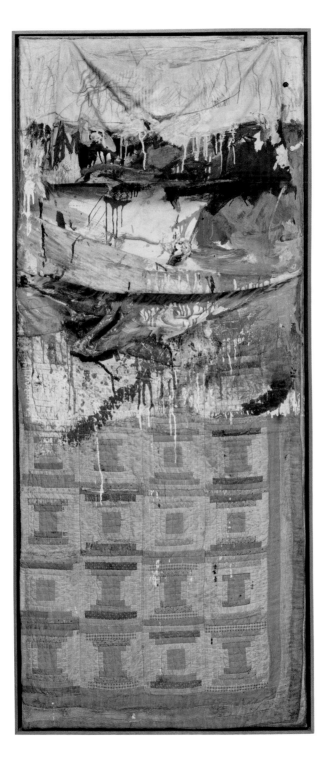

would allow the messy bits of his pigment to run in downward rivulets over the pillow, sheet, and quilt.

It is more than likely that the artist had formal, compositional reasons for wanting those downward vectors in this almost militantly vertical painting. Given Rauschenberg's extreme sensitivity to the connotative powers of his materials, it is difficult to imagine that he would not have foreseen a bed, an obviously used bed, smeared with red, yellow, blue, brown, white, and magenta paint as so many invitations to readings of violence, impurity, and sexual mayhem—but a body lying on the bed, whether being murdered or expelling fluids, would not leave trails of stuff running *down* its surfaces. If this evidence of artful practice as opposed to indexical trace might require a particularly observant parsing, Rauschenberg more obviously emphasizes the object's pictorial qualities in his use of the quilt. First, its repeated pattern of rectangles contrasting with his extravagant latherings of paint forces an encounter between geometric and gestural abstraction. And second, where he had earlier required a model to lie on light-sensitive paper spread on a hard floor in order to

16

5 Rauschenberg exposing blueprint paper to light, West 96th Street, New York, spring 1951. Wisconsin Historical Society (WHi-66573)

preserve the ghostly record of her presence in a blueprint (fig. 5), here he enlisted no collaboration. The soft surface of the quilt is undisturbed—tidily made, it bears no imprint of an occupant.

Rauschenberg wanted, he often said, to operate "in the gap between art and life." The limbo *Bed* inhabits between painting and felt experience hovers close to that ambition. In one ambiguous place, it conflates the private retreat of the bedroom and the public display of art. In the "friendliest" of manners, it unmakes distinctions, coaxing opposites into cooperative action.

Rebus (1955) "There is no reason," Rauschenberg
said, "not to consider the world as a gigantic painting." That all-embracing vision of the environment as a vast image bank sustained the artist's prolific and widely varied creative activity over nearly six decades. According to his friend Jasper Johns, he was the most inventive modern artist since Picasso. Linking them most significantly is collage, invented by Picasso in 1912 and reinvented by Rauschenberg between 1954 and 1964 with hybrids of painting and sculpture he called Combines. With these works, collage was transformed from a Cubist-derived process that assembles commonplace materials to serve illusion into a process that undermines both illusion and the idea that a work of art must have a unitary meaning.

Rauschenberg made *Rebus* at a moment in his career when, as critic John Russell commented, he had "just discovered the poetics of glut, and he couldn't wait to tell us about them."

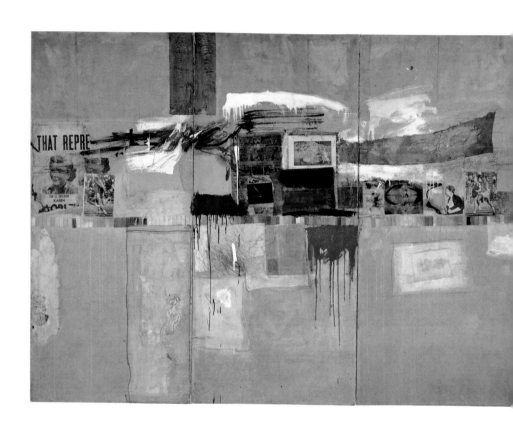

Rebus 1955
Oil, synthetic polymer paint, pencil, crayon,
pastel, cut-and-pasted printed and painted
papers, and fabric on canvas mounted
and stapled to fabric, three panels,

overall 8' x 10' 11 ⅛" (243.8 x 333.1 cm)
The Museum of Modern Art, New York.
Partial and promised gift of Jo Carole and
Ronald S. Lauder and purchase, 2005

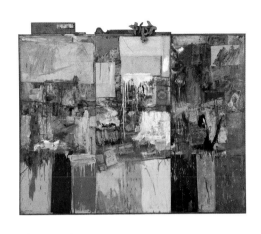

Conceived within this new reportorial frame of mind, *Rebus* has little of the nostalgic, even intimate character pervasive in works like *Collection* (fig. 6) from the previous year. Although all of the "attachments" in *Rebus* are personal, in that they came from the artist's studio or are things he found in his Lower Manhattan neighborhood, Rauschenberg used them in a spirit of dispassionate survey. In his words, this monumental "no color" Combine was intended to be "a concentration of that particular week in that particular neighborhood." Part of what he called his "pedestrian series," *Rebus*, as Roberta Bernstein observed, "looks like a weathered cement wall with posters and ads on it that we might see" walking through downtown Manhattan's gritty streets. But, as Bernstein recognized, it has other outside connections. To anyone familiar with twentieth-century art, *Rebus* might evoke Marcel Duchamp's *Tu m'* of 1918 (fig. 7) as readily as it does a wall. Like Duchamp's picture, Rauschenberg's features an ordered stripe of commercial color samples and a truncated phrase that provokes a Pavlovian reader response in the viewer. In the Rauschenberg, "THAT REPRE" on a newspaper fragment at the upper left immediately clicks into "that represents"; in the Duchamp, the eponymous *Tu m'* in white paint at the lower left

6 *Collection* (formerly *Untitled*) 1954
Oil, paper, fabric, wood, and metal
on canvas, 6' 8" x 8' x 3 ½" (203.2 x
243.8 x 8.9 cm)
San Francisco Museum of Modern Art. Gift
of Harry W. and Mary Margaret Anderson

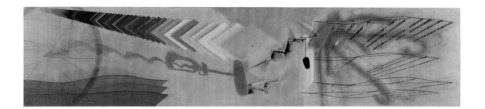

switches on "you/me." In both instances, the subject of the artist's experiment—the viewer—is left to speculate about the referents of the text.

As is typical throughout the Combine series, Rauschenberg countered what he called "the almost overpowering influence of Abstract Expressionism" by enlisting various of its individual manners of paint handling as anonymous collaborators. For example, at the upper left, over a broadly brushed opaque yellow rectangle, a thickly impastoed blur of red, black, and blue paint—some of it squeezed directly from the tube—cuts across thin washes of white, translating a contrived frenzy of execution into an emphatic directional thrust reinforced to the right by a sweep of red silk. In other borrowings from the Abstract Expressionist repertoire, an elongated swath of matte white in the upper center was allowed to dribble down like a melting thatched roof toward a large square of collaged Li'l Abner and Pogo comics. Below, and texturally similar to the white above, are two roughly contoured rectangles. The messy brown one to the left sits on top of the lateral line of color samples that divides the picture; on the right, an even messier red one hangs from it. While flaunting their origins in Abstract Expressionist facture,

7 Marcel Duchamp (American, born France. 1887–1968)
Tu m' 1918
Oil on canvas, with bottle brush, safety pins, and bolt, 27 ½" x 9' 11 ⁵⁄₁₆"

(69.8 x 303 cm)
Yale University Art Gallery, New Haven, Connecticut. Gift from the Estate of Katherine S. Dreier

these painterly areas, in common with other components of *Rebus*, were assigned formal duties. Here, they emphasize and loosely define a zone of relative density in the center of the picture's middle panel.

Although called *Rebus*, this picture doesn't quite stick to the rules. A rebus is a word-image riddle in which images spread out like a line of type can be puzzled through to arrive at the only correct reading (where, for example, a picture of an eye stands for "I"). Far from proposing any final, correct decoding, *Rebus* entices the viewer into an open-ended game of maybe. Rauschenberg often said that a work of art perfectly understood is dead. By that logic, *Rebus* is not endangered.

Rhyme (1956) Rauschenberg has said that he approached the making of his Combines with the "idea of a gentle cacophony." A great many of these boisterous, discordant assemblages suggest that cacophony had the higher priority. Not so *Rhyme*, even if its comparatively well-bred bearing only partially veils its author's taste for dissonance. Rauschenberg usually titled his works after completion, and here his choice may acknowledge a certain accommodation to formal decorum. There is, for instance, that madly careening passage of impastoed bravura in the center, which establishes a kind of conceptual kinship with the horses in the middle of the odd, necessarily attenuated Southwestern landscape in the necktie at left. (One horse-loving, non-modern-art-loving guest of the painting's

21

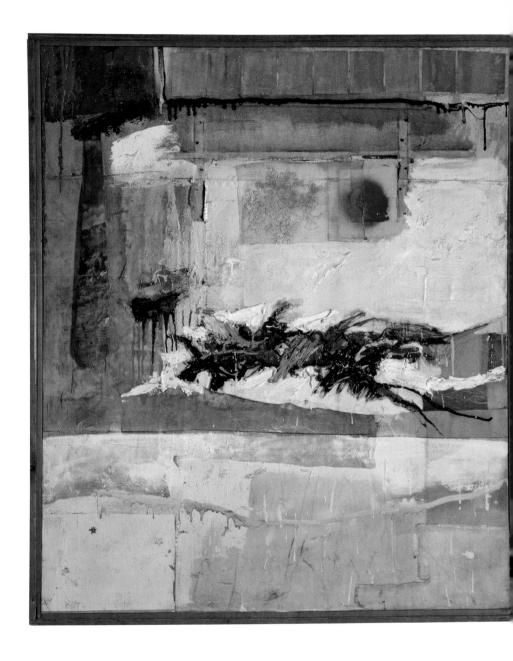

Rhyme 1956
Fabrics, necktie, paper, oil, enamel, pencil,
and synthetic polymer paint on canvas,
48 ¼ x 41 ⅛" (122.6 x 104.4 cm)
The Museum of Modern Art, New York.
Fractional and promised gift of Agnes Gund
in honor of Richard E. Oldenburg, 1994

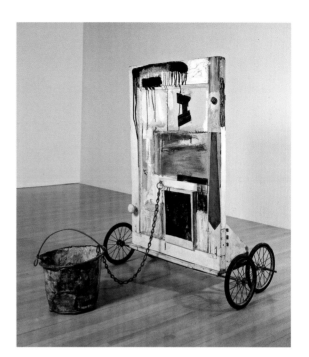

former owner dropped his aesthetic bias when he perceived a resemblance between that swift passage of paint and a race-horse in action.)

Why, one might ask, is there a necktie in this array of collaged materials? For one thing, it is a fine and gendered foil for the dainty, doilylike square of embroidery to its right. Then there is Rauschenberg's fondness for neckties, which, in an interview late in his life, he put in a class with tires and wheels as superior, always available tools of construction. However he might use one, in *Rhyme, Levee* (1955), or *Gift for Apollo* (1959) (figs. 8 and 9), its presence is useful as a reminder of the real scale of the world—in this case with added irony, since a slice of vast landscape is compressed within its borders. And, in each

23

evee 1955
paper, printed paper, printed
roductions, fabric, and necktie
canvas, 55 x 42¾" (139.7 x 108.6 cm)
ate collection

9 *Gift for Apollo* 1959
Oil, pant fragments, necktie, wood, fabric,
newspaper, printed paper, and printed
reproductions on wood with metal bucket,
metal chain, doorknob, L-brackets,

metal washer, nail, and rubber wheels with
metal spokes, 43¾ x 29½ x 41" (111.1 x
74.9 x 104.1 cm) (depth variable)
The Museum of Contemporary Art, Los
Angeles. The Panza Collection

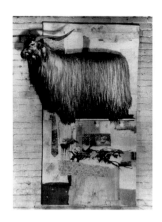 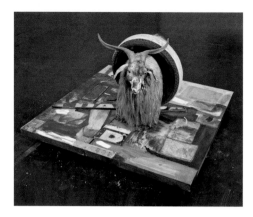

instance, its verticality alternately counters and echoes surrounding horizontal and upright bands of material.

The multiple layers of paper, fabric, and paint assembled on *Rhyme*'s surface interact with casual symmetry. At the bottom a sagging strip of white paint traversing the canvas manages to look more like a clothesline for drips than a once viscously dribbling unity. At the top that effect is repeated and abbreviated in a horizontal band of green pigment that stops just even with the left edge of a strip of ten neatly collaged brown rectangles. The unusual regimentation of those rectangles responds with an insistent visual staccato to the loose rectilinear patterns dominating the picture's overall structure.

Beyond these and other pictorial reciprocities at play in *Rhyme*, there is a dialogue going on with a large ghost. When, sometime in 1955, what would be *Rhyme* was sixteen inches taller but not a great deal wider (fig. 10), it was briefly home to Rauschenberg's famous stuffed Angora goat, now permanently at rest in *Monogram* (1955–59) in the Moderna Museet in Stockholm (fig. 11). *Rhyme* has not, however, forgotten the goat's brief passage. A thin line beginning at the upper-right edge proceeds between two now-empty nail holes, skims over the top of the

24

10 *Monogram* first state, c. 1955
Oil, paper, fabric, and wood on canvas with stuffed Angora goat and three electric light fixtures, 6′ 3″ x 46 ½″ x 12″ (190.5 x 118.1 x 30.5 cm) (approx.)
No longer extant

11 *Monogram* 1955–59
Oil, paper, fabric, printed paper, printed reproductions, metal, wood, rubber shoe heel, and tennis ball on canvas with oil on Angora goat and rubber tire on wood platform mounted on four casters, 42 x 63 ¼ x 64 ½″ (106.7 x 160.7 x 163.8 cm)
Moderna Museet, Stockholm

brilliant red circle through its embroidery neighbor, and continues until it is directly below the left edge of the horizontal green strip, where it breaks. Commemorated in that fragile trajectory is the ledge on which Rauschenberg's goat once stood. The reddish-brown slant-edged area of paint obscuring the top of the tie appears exactly where the tie disappeared beneath the goat's cascading hair. In other "coincidences," the red circle, almost luminescent against its gleaming yellow ground, happens to be just about where the first of three electric lights were suspended from the ledge. Rauschenberg once said, "I always have a good reason for taking something out but never one for putting something in." Self-editing has, of course, always been part of the artistic process, but the Rauschenberg way of doing it was not unlike that of the gestural faction of classic Abstract Expressionism. Paint might fly and splatter, but what the viewer sees in the end is the sum of the taking outs.

Factum II (1957) One definition of *factum*

is "A man's act and deed." It is also defined as "A statement of the facts in a controversy or legal case." Rauschenberg's paintings *Factum I* (fig. 12) and *Factum II* embody the artist's act and deed in a statement that tests key tenets of Abstract Expressionism. He made them when, as he accurately recalled, "There wasn't any resistance to the abstract expressionists. . . . I think only Jasper Johns and myself gave them enough respect not to copy them."

Visitors take in the exhibition *Robert Rauschenberg* at The Jewish Museum, New York, 1963. In the foreground is *Monogram* (1955–59). *Rebus* (1955) is at right. Photograph by Hans Namuth

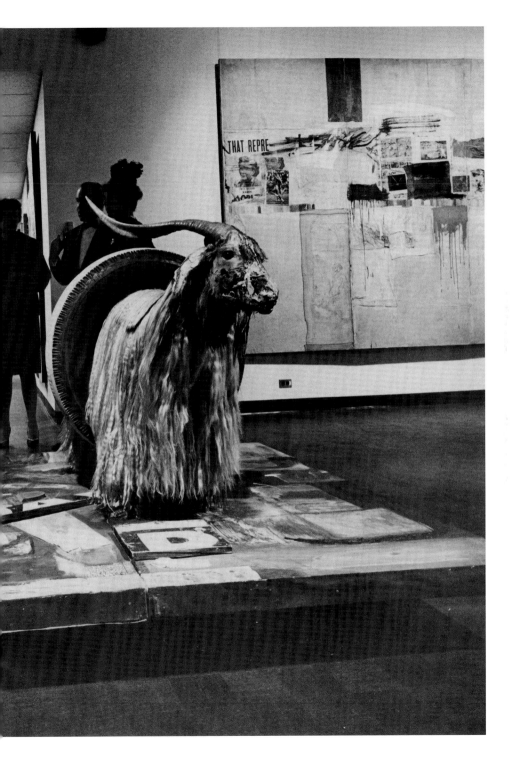

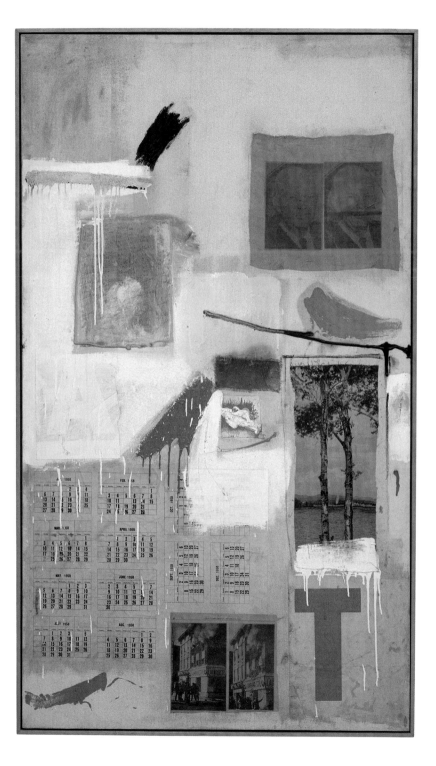

Conceptually, the making of these twin paintings parallels Rauschenberg's unmaking of a drawing by Willem de Kooning two years earlier. Both actions came from Rauschenberg's profound admiration for the breakthrough achievements of his predecessors—"the freedoms that [they] indulged in changed the possibilities and limitations of every artist"—and a respectful but demanding Oedipal urge. Amazingly, De Kooning understood these conflicting impulses and, at Rauschenberg's request, gave him a drawing to erase. The original sheet bearing faint traces of the marks of one artist and the erasures of the other has long been preserved in a gold frame bearing the words "Erased de Kooning Drawing / Robert Rauschenberg / 1953" (fig. 13). By late 1957 Rauschenberg needed to expand this negative act of homage and exorcism in larger, more positive terms.

The terms, of course, were his. As Rauschenberg pointed out, he and Johns did not copy Abstract Expressionism. His test example, *Factum I*, was not an "action" painting found through the struggle of its making, but a typical Combine juxtaposing painting and selected (found) materials. But aside from a possible disparity in speed of execution and the use of collage, Rauschenberg produced *Factum I* through a process analogous

29

um II 1957
nk, pencil, crayon, paper, fabric,
spaper, printed reproductions,
painted paper on canvas, 61 ⅜ x 35 ½"
9 x 90.2 cm)
hase and an anonymous gift
Louise Reinhardt Smith Bequest
n by exchange), 1999

12 *Factum I* 1957
Oil, ink, pencil, crayon, paper, fabric,
newspaper, printed reproductions,
and painted paper on canvas, 61 ½ x 35 ¾"
(156.2 x 90.8 cm)
The Museum of Contemporary Art, Los
Angeles. The Panza Collection

to Abstract Expressionism's classic practice. In March 1958, when it was first shown at the Leo Castelli Gallery along with its carefully fabricated replica, *Factum II*, the question of whether the first, spontaneously composed picture possessed virtues its near but slightly different twin did not became an unsettling conundrum. While the puzzle did cast shadows on the mystique of Abstract Expressionism, its more immediate effect was to shift attention to the person who had devised it. The show itself caused Leo Steinberg to revise his previous dismissal of Rauschenberg, and the copied *Factum* "forced" Robert Rosenblum "to admit that the same combination of impulse and discipline that produces more conventional pictures is also operating here."

 Corollary to their mission to undermine Abstract Expressionist doctrine, *Factum I* and *II* were primed to elicit viewer responses like Rosenblum's: by "forcing" a search for their differences, they snare the seeker in a game about uniqueness and doubling. Mechanically reproduced and glued to the surface of the canvas, the paired but not quite identical photographs—sequential shots of a burning building—have considerable in common with neighboring abstract brushstrokes. As the two paintings demonstrate, these "random" marks are also, with the

30

13 *Erased de Kooning Drawing* 1953
Traces of ink and crayon on paper, mat, label, and gilded frame, 25 ¼ x 21 ¾ x ½" (64.1 x 55.3 x 1.3 cm)
San Francisco Museum of Modern Art.
Purchased through a gift of Phyllis Wattis

slightest variations, repeatable and available for collage.

The *Factum*s are, as characterized by Kirk Varnedoe, "a complex meditation on variety and sameness," but they are less meditative in spirit than jolly. They latch on to their subject with engaging exuberance. To start off, there is that big, red stenciled "T" for two; two trees, two Ikes, two calendars in two directions, two buildings, and too much more to inventory here. Inhabiting the two paintings is Rauschenberg's belief that humor is the objectivity of vision.

Canto XXXI: The Central Pit of Malebolge, The Giants (1959–60) Rauschenberg
explained his series of drawings after Dante Alighieri's *Inferno* (c. 1314) as an attempt "to see if I was able to do narrative work, like Dante." He often remarked that he had peculiar vision, that he "tended to see everything in sight." It must have been that scope that led him to light on Dante as a collaborator at a moment when Pop art (much encouraged by his own earlier work) was engaged in a breathless pursuit of the contemporary. In early 1959 he began his illustrations of Dante's fourteenth-century epic, following its development in strict chronological order, canto by canto, until the thirty-four drawings of the suite were finished some eighteen months later.

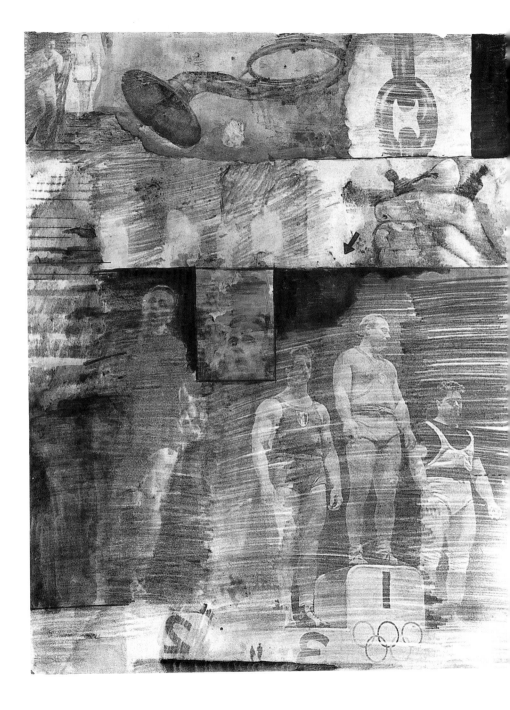

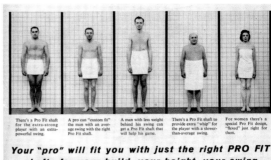

Canto XXXI: The Central Pit of Malebolge, The Giants, showing Dante and his guide, Virgil, in the eighth circle of Hell, is representative of Rauschenberg's success in "doing a narrative, like Dante." Essential to the equivalencies between words and images Rauschenberg devised here and throughout the series is his brilliant use of a new transfer technique. Halfway between printing and drawing, each of the thirty-four illustrations was achieved through a process of such simplicity that children commonly experiment with it. Rauschenberg moistened the surface of a sheet of paper with a hydrocarbon solvent—often lighter fluid or turpentine—placed a reproduction found in the popular press face down on the moistened area, then, scribbling over it with a pencil, empty ballpoint pen, or some such instrument, made a drawing in which the displaced, reversed imagery exists within the scribbles that produced it. The result, often enhanced by pencil and gouache, transforms representations of the tangible into shadows of themselves, yet the images retain the evidentiary credibility of the photograph.

In this drawing Rauschenberg shows the traveling poets— whose identities are multiple in his *Inferno*—at the top left, entering the central pit of Malebolge in the eighth circle of Hell.

33

*to XXXI: The Central Pit of Malebolge,
Giants* from the series Thirty-Four
trations for Dante's Inferno 1959–60
sfer drawing, colored pencil,
ache, and pencil on paper, 14 ½ x 11 ½"
3 x 29.3 cm)
Museum of Modern Art, New York.
n anonymously, 1963

14 Advertisement for True Temper Pro
Fit golf shafts (detail), *Sports Illustrated,*
May 19, 1958

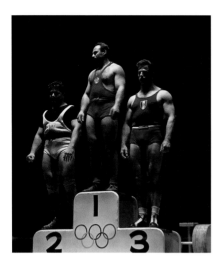

Virgil is the robust athlete, and Dante is in his frequent guise as a man wrapped in a towel, an image taken from *Sports Illustrated* (fig. 14) and perhaps inspired by the author's address to himself in the last canto: "Each sinner swathes himself in his own torment." Several times the size of the wandering duo, the adjacent, snakelike horn refers to the thunderous noise that greeted them, and next to it are links in the chains fettering the giants who had rebelled against the Gods. Below is the huge hand of the only unchained titan, Antaeus. Convinced by Virgil that Dante's pen will increase his fame if he gets them to Hell's ninth and last circle, Antaeus grips the wanderers and—following Rauschenberg's directional arrow—is about to drop them at their destination. At the left, in the largest of the drawing's three horizontal bands, is stumbling, lunatic Nimrod, doomed to babble gibberish through all eternity for building the Tower of Babel; the red-bordered inset framing an inchoate repetition of his open-mouthed face encapsulates his punishment. The largest area of the composition is assigned to the giants—three hefty

34

15 Middle-heavyweight weight-lifting medalists at the 1956 Olympic Games (USA: David Sheppard; USSR: Arkady Vorobyev, France: Jean Debuf), November 22, 1956. *Sports Illustrated*, January 7, 1957

Olympic weight lifters also taken from *Sports Illustrated* (fig. 15). The three of them, the prominently jumbled numbers of their rankings, plus the compositional division of the drawing sheet itself are Rauschenberg's transpositions of Dante's prevailing schemes of three—his homage to the *terza rima* rhyme scheme the poet invented in honor of the Holy Trinity.

Whatever drama the drawing's characters may possess owes largely to the tonal haze left by the scribblings of the transfer process. Lawrence Alloway called it "a kind of soft dazzle in which objects hover and dissolve in light . . . somewhere between a grid and a snowstorm." At the bottom of the sheet, left center, are the miniscule figures of Dante and Virgil again, presumably having just descended through the thick murk above. Therein is Rauschenberg's most ingenious tie to what Dore Ashton identifies as "Dante's unity," the evocation in almost every canto of palpable atmosphere, of "howling winds, murmurs, blasts." Rauschenberg, she says, matches "the rolling continuity of Dante . . . in the spirit rather than the letter." Should objections persist about the common origins of Rauschenberg's motley crews—weight lifters, sweating athletes, and so on—it may be pointed out that they too match Dante, who wrote in vernacular Italian rather than Latin and who, in 2000 A.D., elicited this comment from a professor at Princeton University: "We can see that Dante's Antaeus is developed from the sort of careful yet freewheeling revision of classical text we are learning to expect from him."

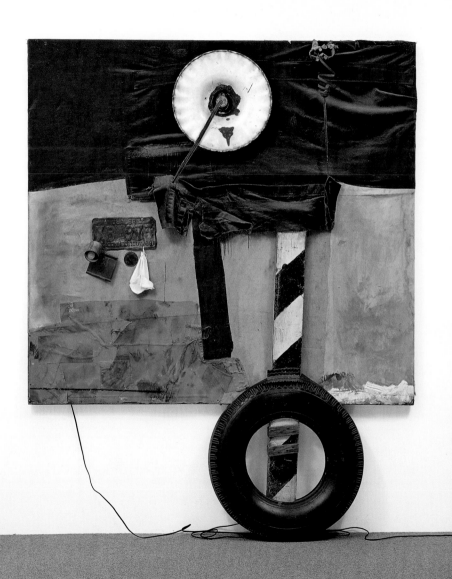

First Landing Jump (1961)

"I don't," said Rauschenberg, "want a picture to look like something it isn't. I want it to look like something it is. And I think a picture is more like the real world when it's made out of the real world." Distinguished by an extreme proximity to the real world, *First Landing Jump* makes every effort to maintain its author's notions of pictorial integrity. Aside from a very few passages of oil paint, every one of its tired, scruffy components comes from the lived-in urban environment. The only possible exception, the work's composition-board support, could have been found in an art-supply or building-materials store. Wherever it came from, its rectangular format is Rauschenberg's one concession to pictorial convention. As here, his Combines' observance of this particular tradition often operates as foil and permission for a multitude of unorthodoxies.

The most prominent transgression in *First Landing Jump* is its break from the bounded space of art into the space of the viewer. John Cage, composer and one of Rauschenberg's closest companions, explained the Combines' predilection for this maneuver laconically: "Some (a) were made to hang on a wall, others (b) to be in a room, still others (a + b)." Lawrence Alloway, commenting on the "perpetually resourceful ways in which the combine paintings join wall and floor," singled out *First Landing Jump*, in which, he said, "a tire is placed to resist impact on the picture it hangs from like a tire on a wharf." If the tire's apparent impact-resisting qualities brought boating to Alloway's mind, it might, given the picture's title, suggest parachute jumping to another, or the animate object itself bouncing down to occupy

st *Landing Jump* 1961
oth, metal, leather, electric fixture,
ole, and oil paint on composition board,
h automobile tire and wood plank,
5 ⅛" x 6' x 8 ⅞" (226.3 x 182.8 x 22.5 cm)
e Museum of Modern Art, New York.
t of Philip Johnson, 1972

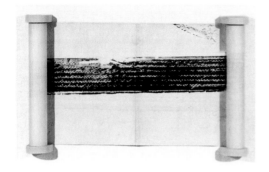

the floor. Another less obtrusive, more literal tie between painting and floor is the electric cord "tying" the two together and supplying power to the blue lightbulb inside the tin can hanging from the license plate at the middle left—the first time the artist incorporated wiring as a visual element in his work. Later, in the mid-1980s, Rauschenberg's response to Barbara Rose's question "What are the most inventive things you've done?" was, "I don't know—screwing lightbulbs into a painting maybe. Adding the luminosity from the painting to match the environment. That was the first evidence I had of wanting the work to *be* the room itself."

Neither the faint illumination emanating from *First Landing Jump* into the surrounding space nor the tire occupying it come close to Rauschenberg's environmental aspiration, but each plays a role in animating the picture. The tire looks rather like it might be part of some kind of hinged contraption, as though a hypothetical tug on the "plank" of torn black tarpaulin in the middle right would lift the striped street barrier into an exchange of positions, readjusting whatever primitive calibrations the white streetlight reflector might be performing. From a much smaller assembly of objects rhyming idiosyncratically with the tire-connected group, the blue lightbulb shines forth

38

16 *Automobile Tire Print* (detail) 1953
Black paint on twenty sheets of paper,
mounted on fabric, 16½" x 22' ½"
(41.2 x 671.8 cm) extended
San Francisco Museum of Modern Art.
Purchased through a gift of Phyllis Wattis

with impenetrable intelligence—aware, perhaps, of its legendary stature in German Romanticism. The tire too has its own iconic status in modernist art from Cubism onward. Its essential implication, as Walter Hopps pointed out, is "mobility—a quality of life in many senses essential to Rauschenberg." Indeed, the tire is historic within Rauschenberg's own art. In 1953 on a "quiet Sunday on Fulton Street," as Hopps described it, "in a collaborative effort, John Cage drove his Model A Ford over twenty-three feet of glued-together sheets of drawing paper as Rauschenberg applied black paint to a rear tire, thus producing the scroll *Automobile Tire Print* (fig. 16). Thereafter—to borrow Hopps's words once more—came "the apotheosis of a Rauschenberg tire (not coincidentally with its black tread painted white)" surrounding the "elegant goat in *Monogram*" of 1955–59 (fig. 11).

As Combines go, the tire-centric *First Landing Jump* is more thematically unified in its display of attachments than most. But, like the others, it does not give itself to the viewer in a single cognitive moment—that initial flash of apprehension claimed by an Abstract Expressionist canvas. Rather, cued by the tire's implications of revolutions in time, the picture taps into the individual viewer's reservoir of experiences.

Mint (1974) Made from silk, gauze, collaged paper bags, and transfer imagery, *Mint* is a flyweight version of the Combine principle. As much as any of those assemblages, it solicits viewer attention through a display of its unusual parts. But

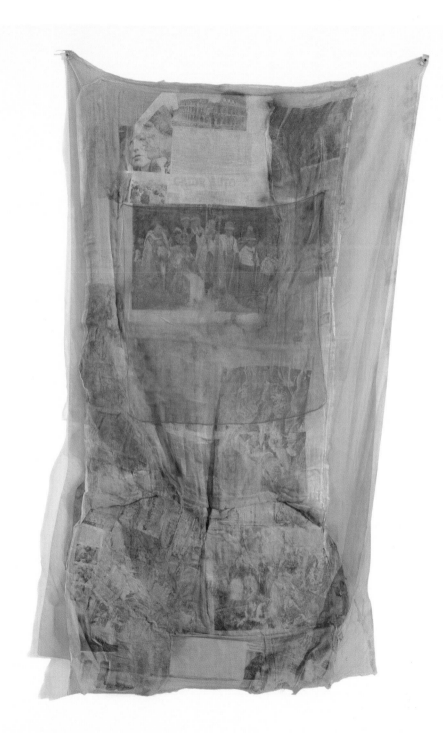

where the materials in a Combine flaunt their physicality, those in *Mint* and the other fabric paintings in the Hoarfrost series whisper discretely of their immateriality. "Their imagery," Rauschenberg wrote, "is presented in the ambiguity of freezing into focus or melting from view," like hoarfrost, the film of ice crystals that forms on frozen surfaces. Rauschenberg was sometimes as intuitively adept with words as images, and his pitch was exquisite when he chose the name for this series. Given that he had made an intense study of Dante's *Inferno* during the course of illustrating it in 1959 and 1960 (see p. 31), it could be that his own work reminded him of the opening image of canto XXIV: "In the turning season of the youthful year, / when the sun is warming his rays beneath Aquarius / and the days and nights already begin to near / their perfect balance; the hoar-frost copies then / the image of his white sister on the ground / but the first sun wipes away the work of his pen."

Rauschenberg explained that the idea for the series came to him in a printmaking studio when, after a day's work, the large sheets of gauze used to wipe stones and presses were laundered and hung about the room to dry. Tom Hess vividly recalled Rauschenberg's rendition of the inspirational moment: "With airy gestures, he describes how the gauzes float in the still air, veiling machinery, prints tacked to walls, furniture." The artist himself said of the series, "I was actually trying to dematerialize the surface as much as I could so that you had a sense of the fabrics being there so the light would have something to fall on." That statement represents nothing so preposterous as an act of charity to "the light" stranded in midair; rather, it is an expression of

nt 1974
k (transfer image) on unstretched silk
d cotton with additional synthetic fabric,
per, and polyvinyl acetate emulsion glue,
6" x 45 ⅞" (198.1 x 116.6 cm) (irreg.)
e Museum of Modern Art, New York.
r. and Mrs. Walter Hochschild and Kay
ge Tanguy Funds, 1977

Rauschenberg's exceptionally activist attitude toward his materials, of which light is the evident *sine qua non*. Ideally his materials were his coevals or, as he said, his collaborators. On another level of cooperative activity—exemplified in *Mint*—the lines of stress the soft material forms after being pinned to the wall are, like variant shafts of light, part of the composition.

Mint's now-you-see-it, now-you-don't imagery is most clearly discernible at the upper middle, in a large picture of a coronation covered in bright-orange gauze. This optical slippage presented in rectangular format is, according to Charles Stuckey, a reference to Josef Albers, "Rauschenberg's most unlikely mentor." Given the format of a typical work by Albers, not to mention his teaching examples (fig. 17), Stuckey is very likely right. The German Bauhaus master had been Rauschenberg's teacher at Black Mountain College in 1948 and 1949 (fig. 18), and despite a hopeless disparity in their personalities, Albers's openness to the use of any and all materials was an attitude that would inform Rauschenberg's work for the rest of his life. It was from him that Rauschenberg adduced, "You don't need paint to make a painting."

42

17 Josef Albers (American, born Germany. 1888–1976) *Illustration IX-I* from *Interaction of Color* (New Haven, Conn.: Yale University Press, 1963).

18 Josef Albers teaching a three-dimensional geometric form exercise, Black Mountain College, Asheville, North Carolina, c. 1948